Easy Coloring
Samantha Moore

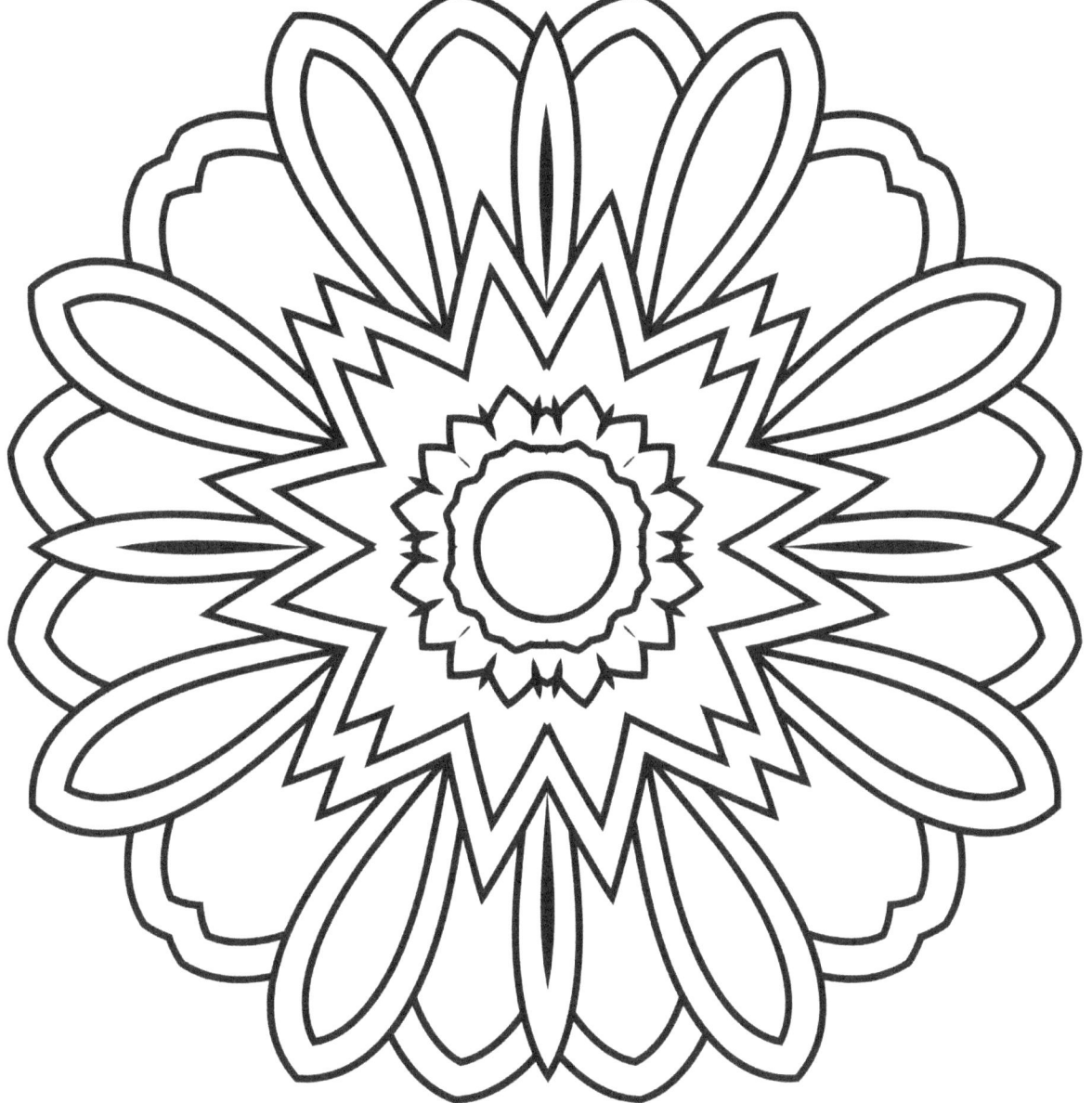

Adult Coloring Book
For beginners, seniors and individuals with low vision

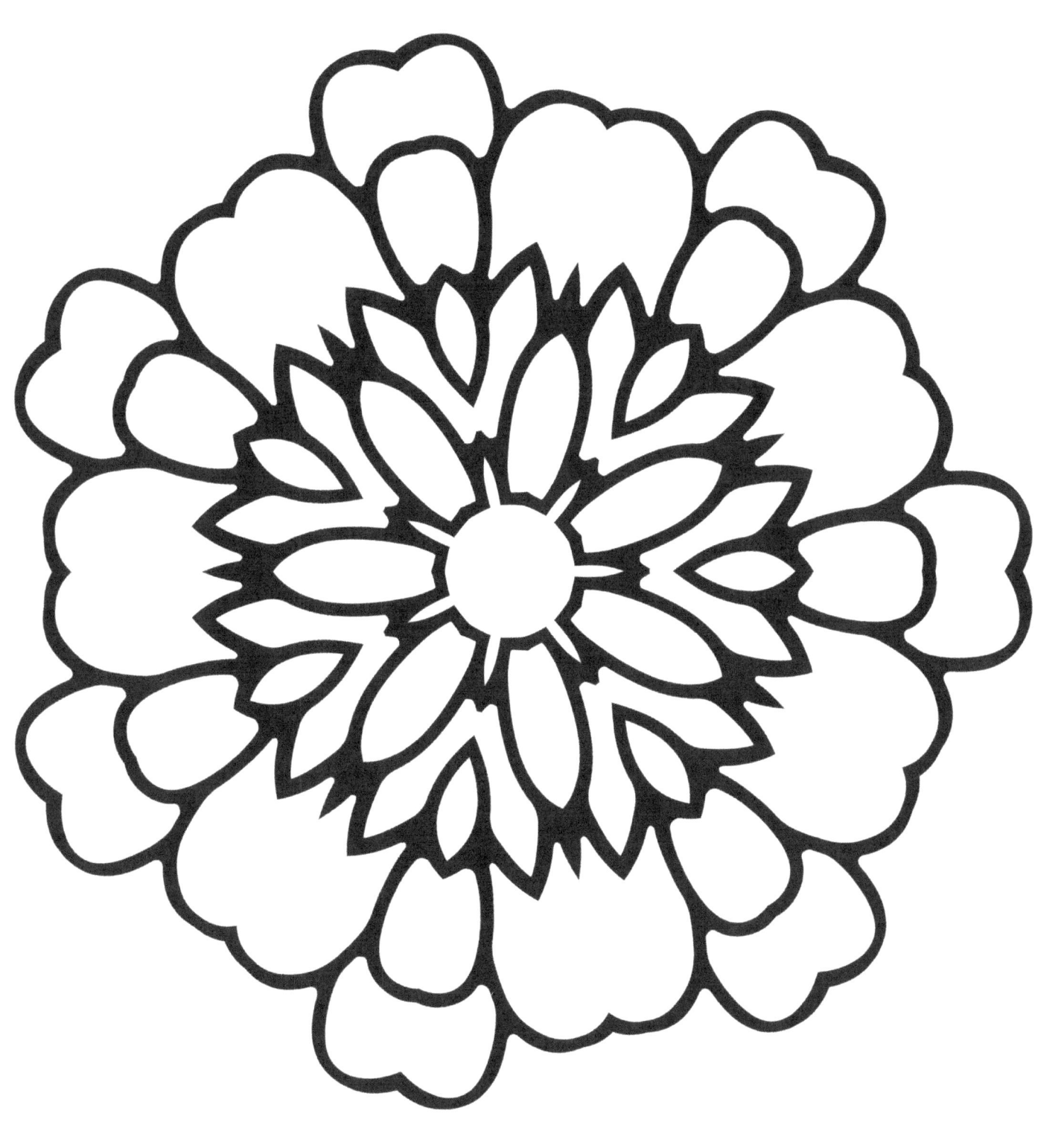

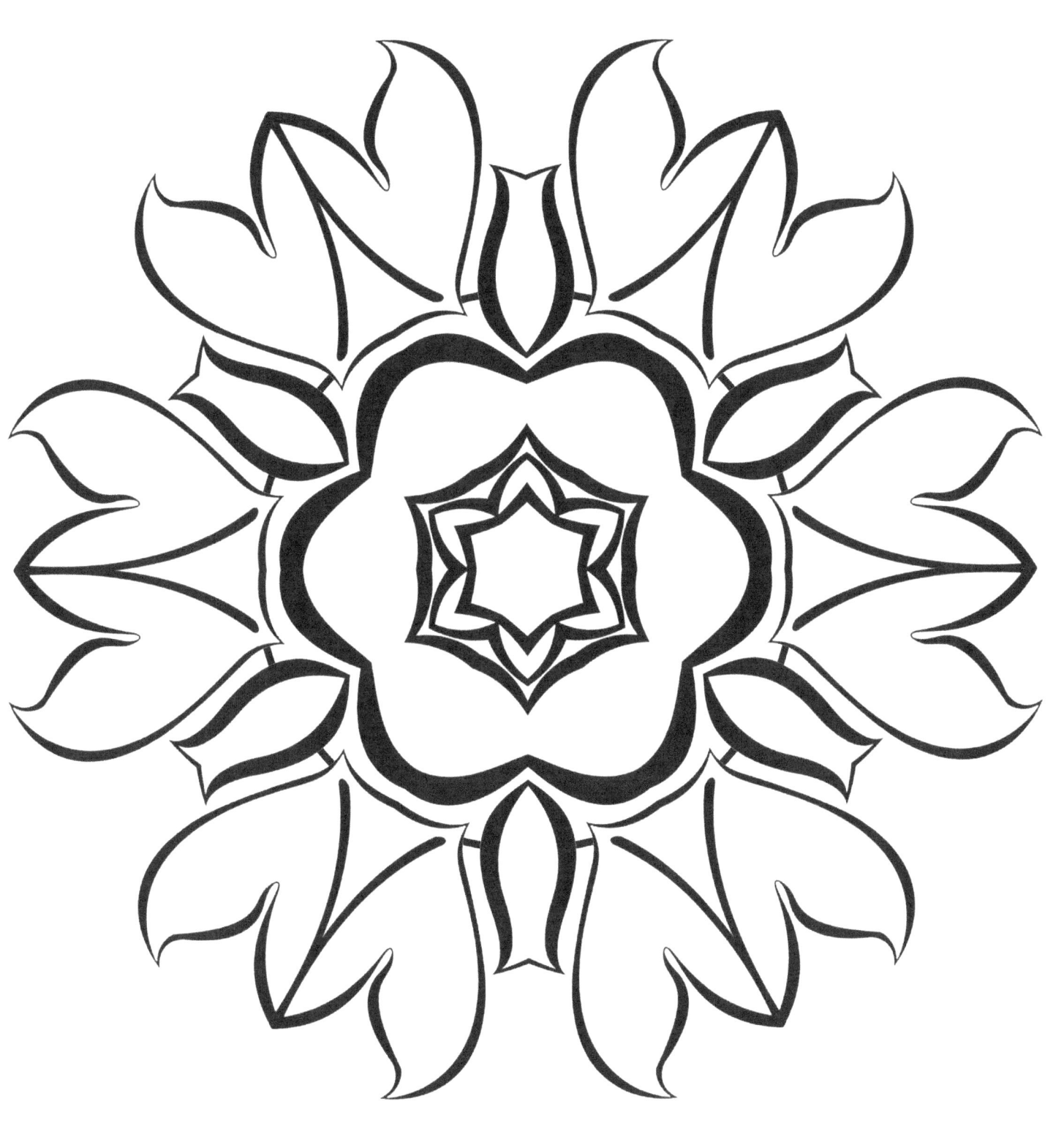

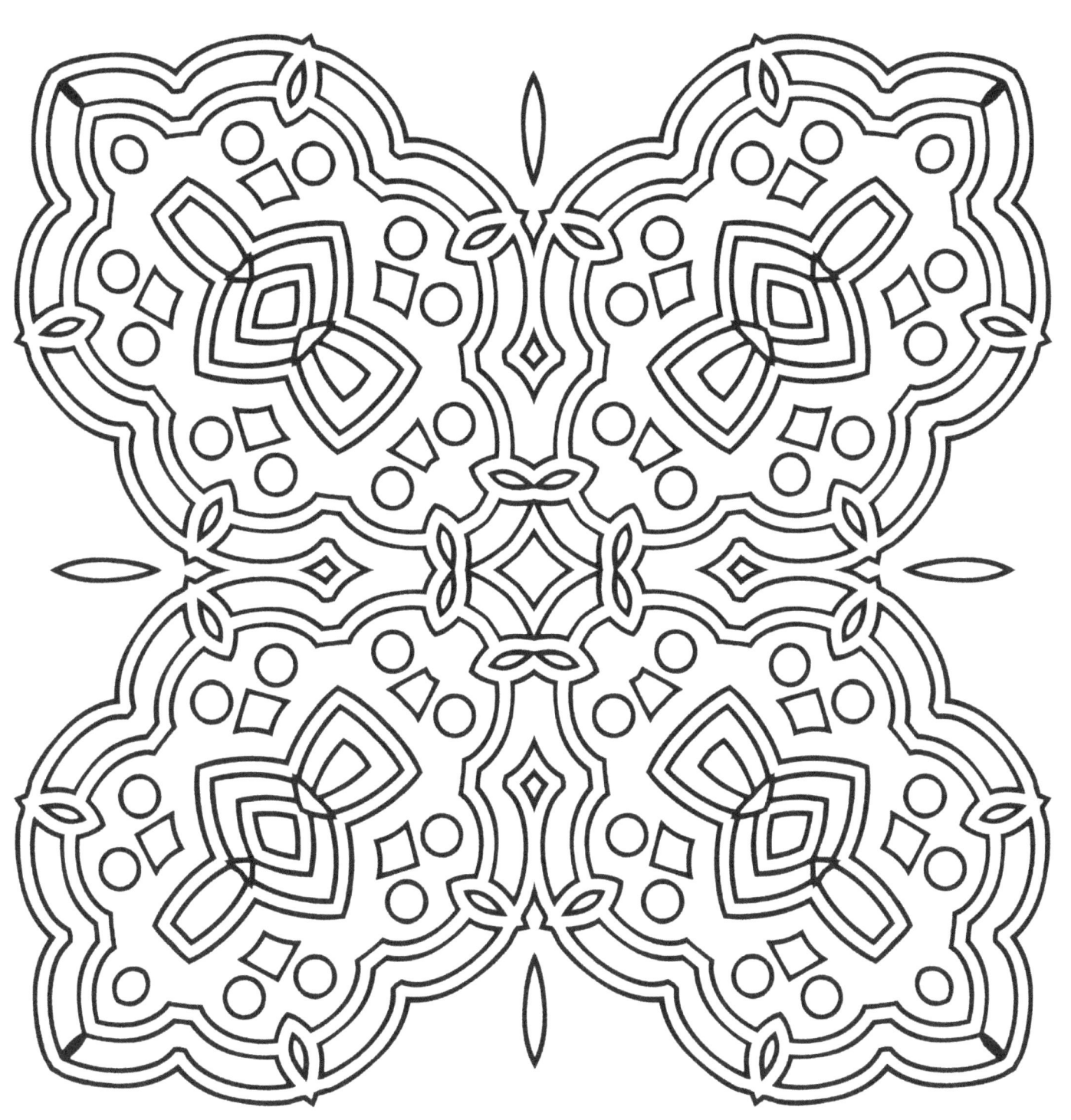

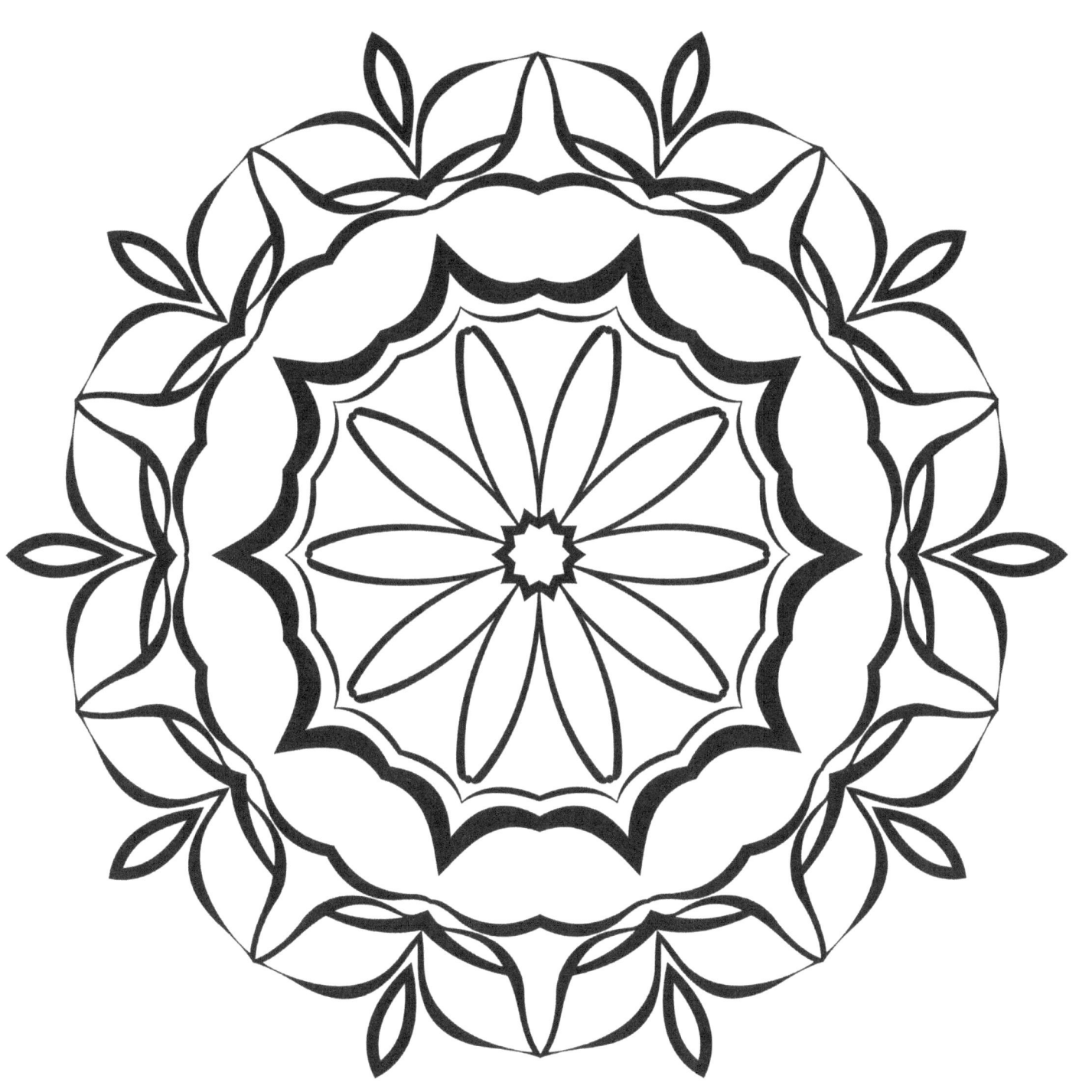

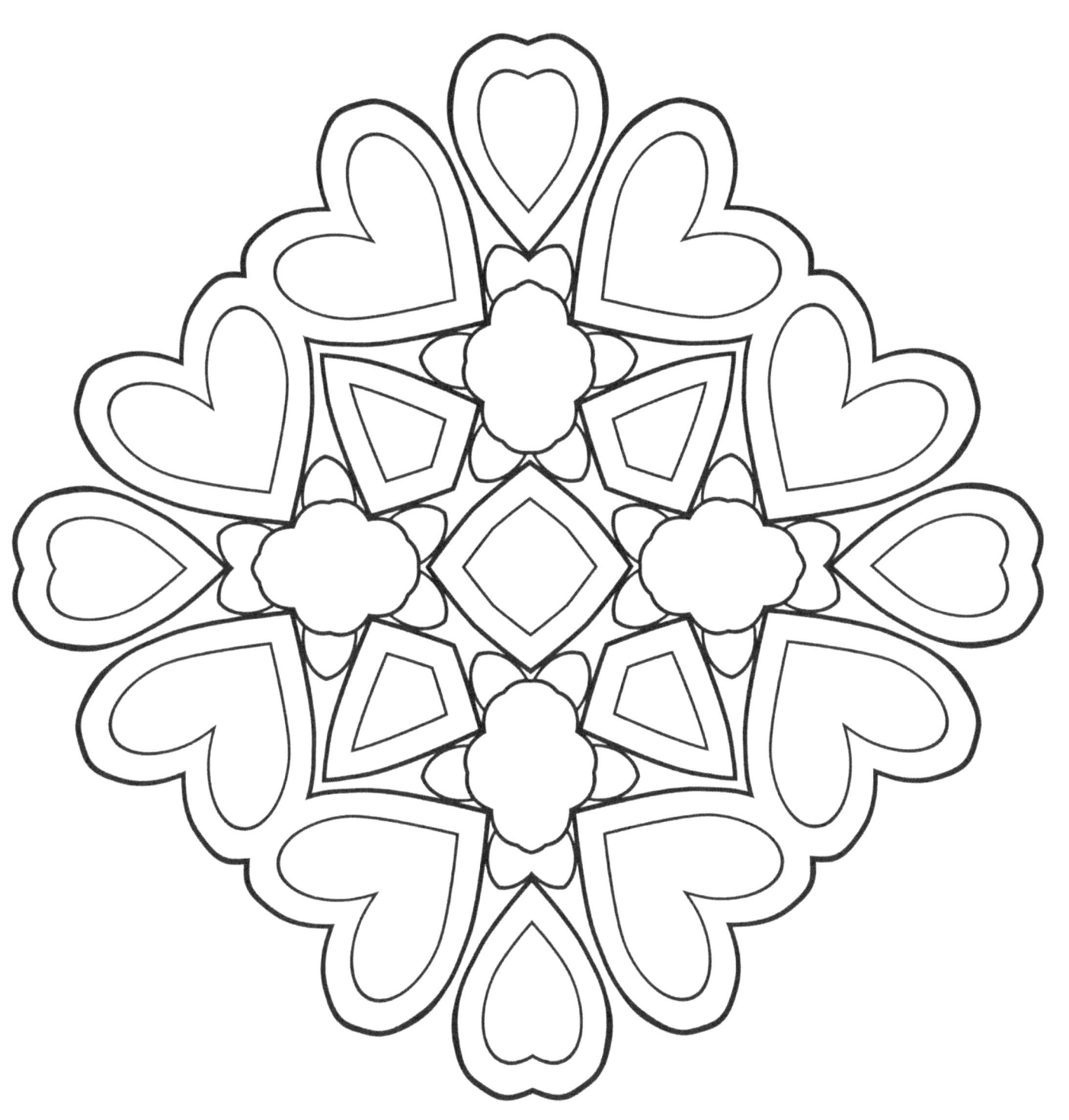

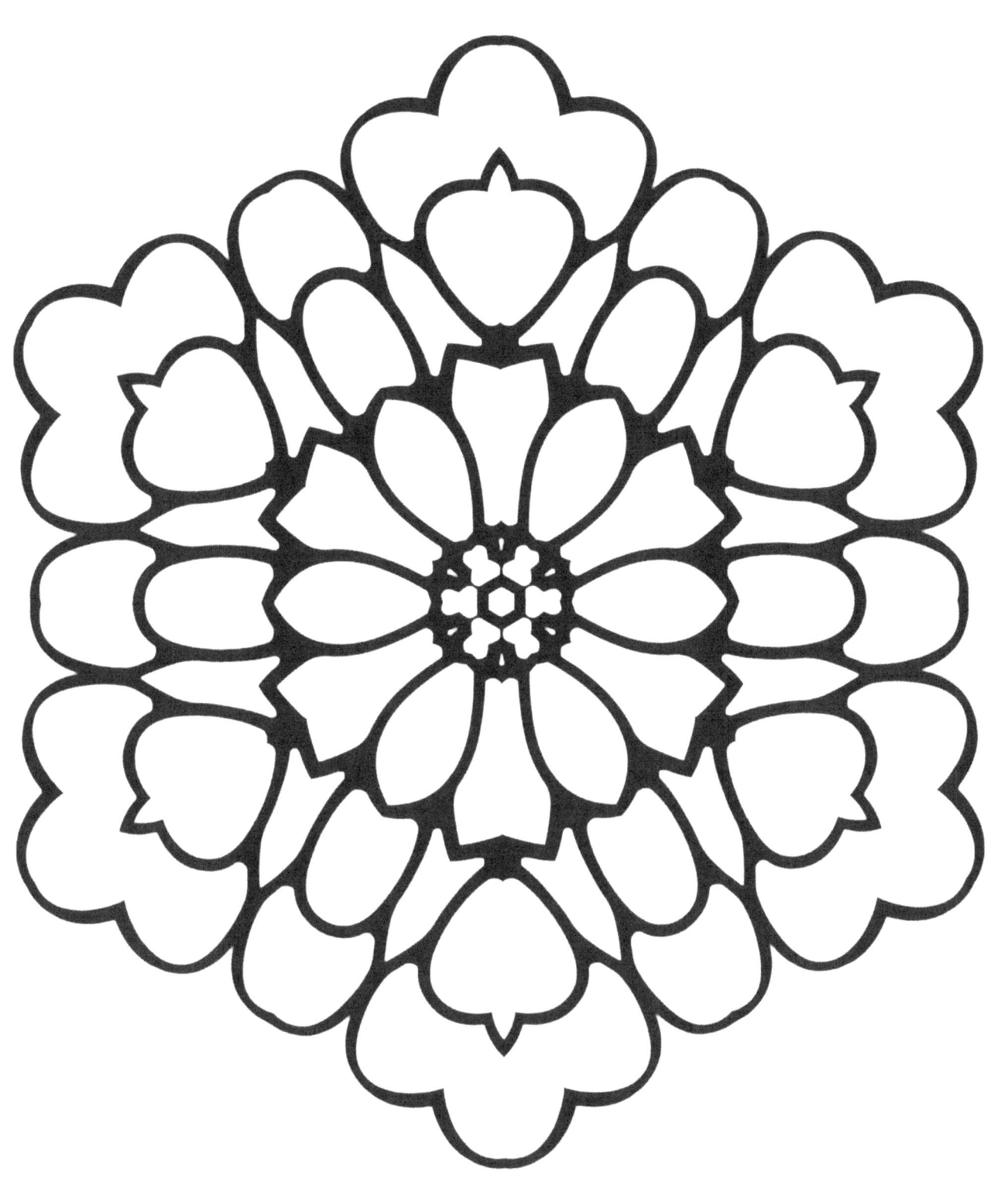

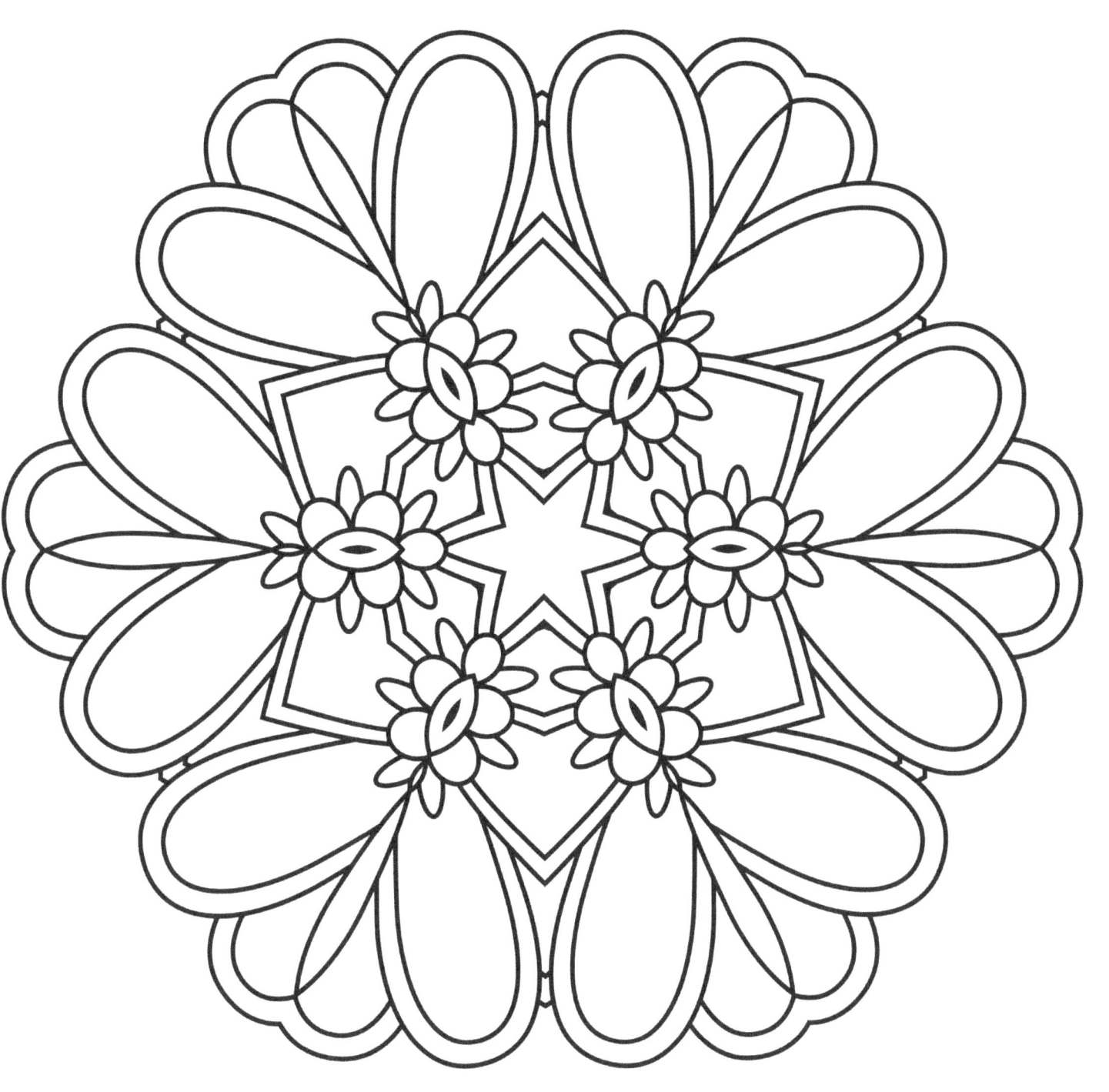

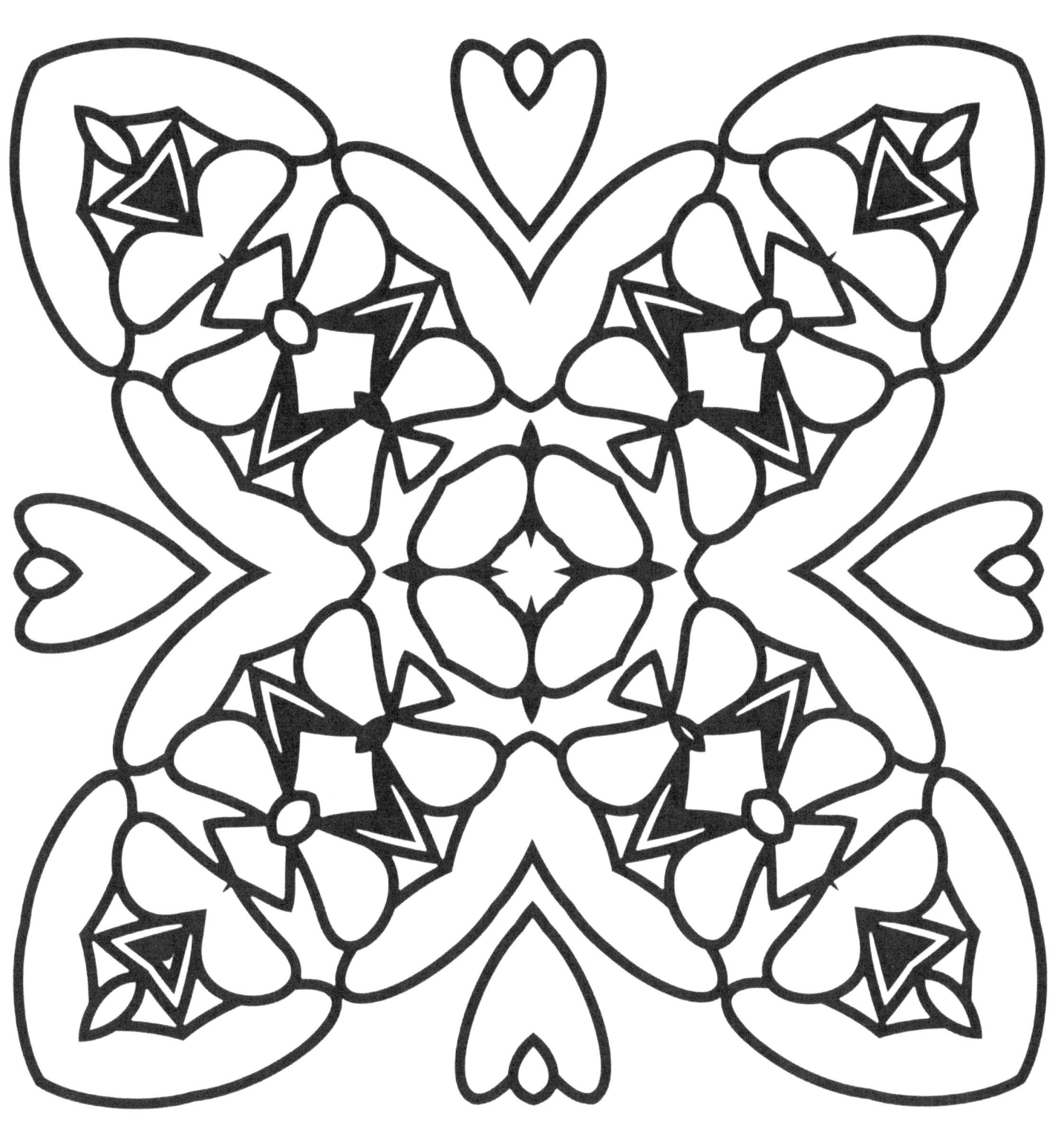

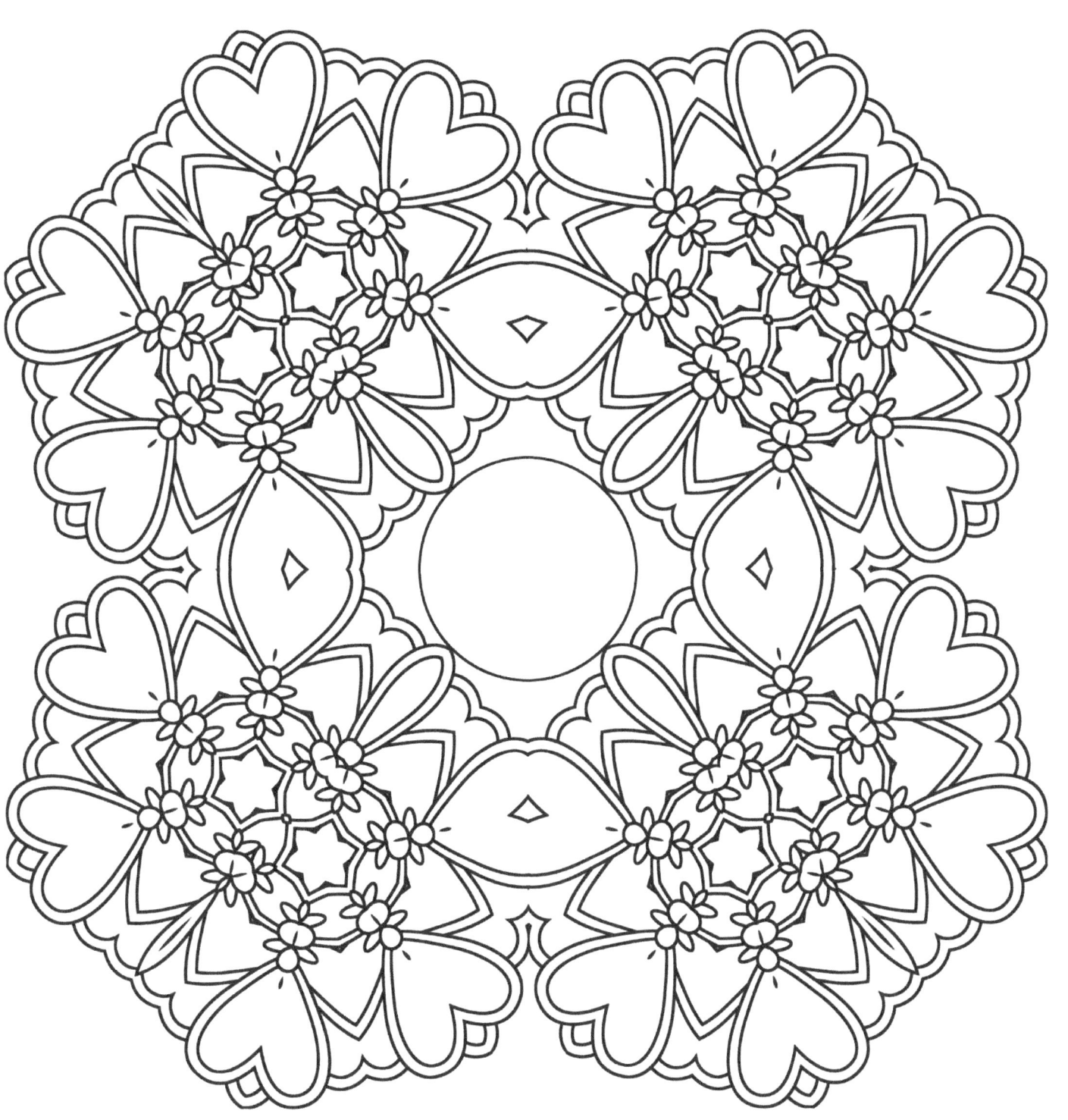

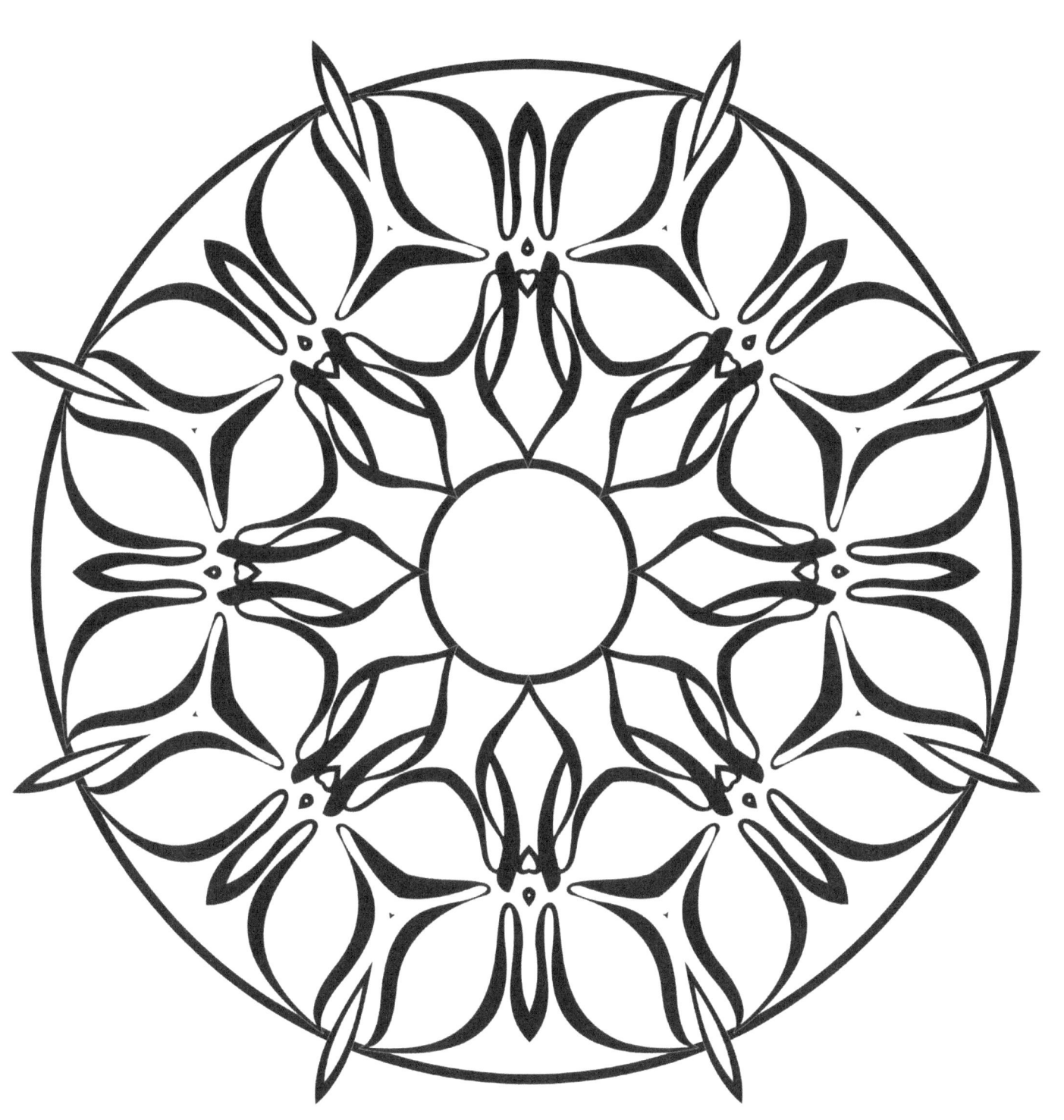

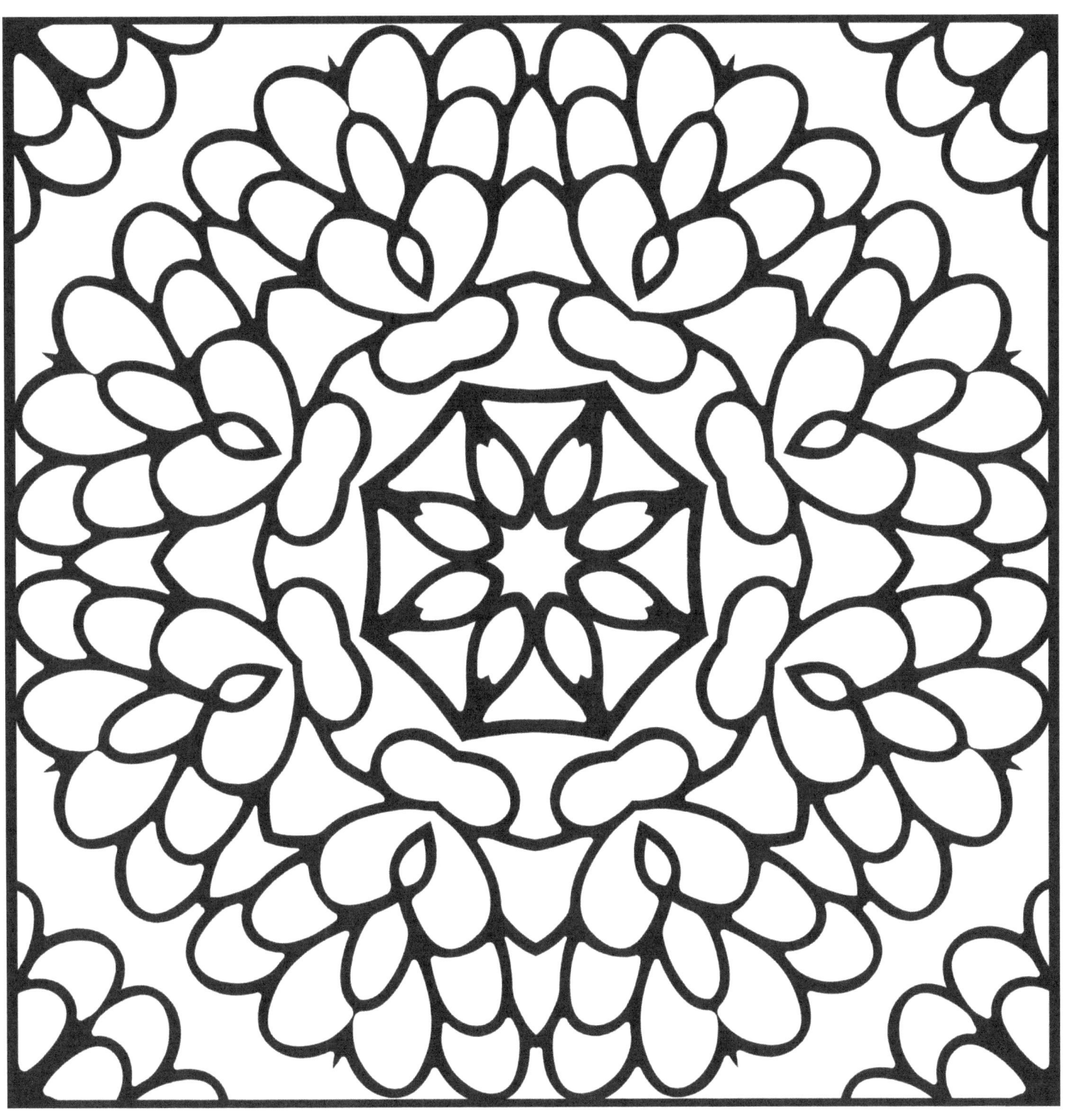

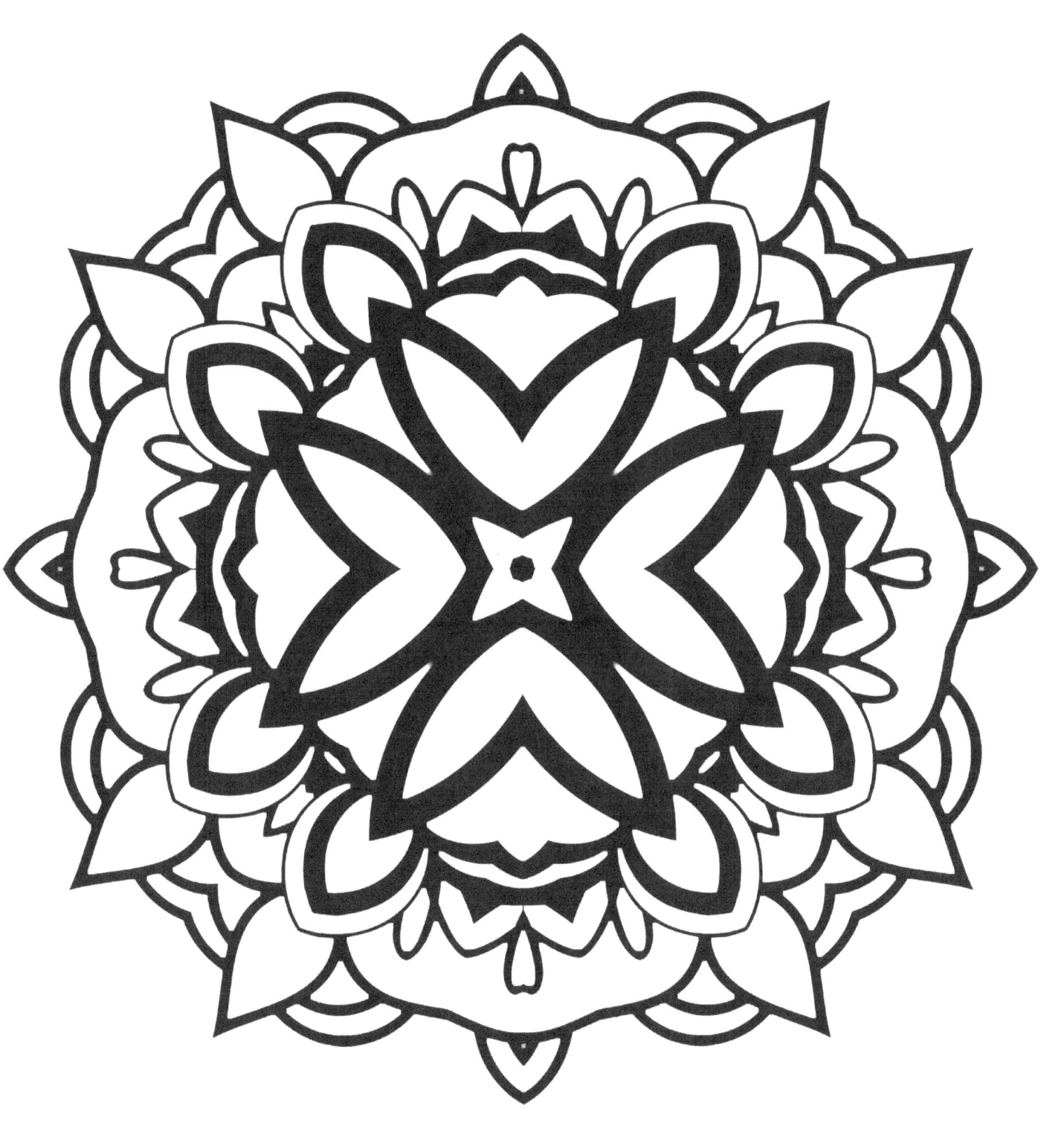

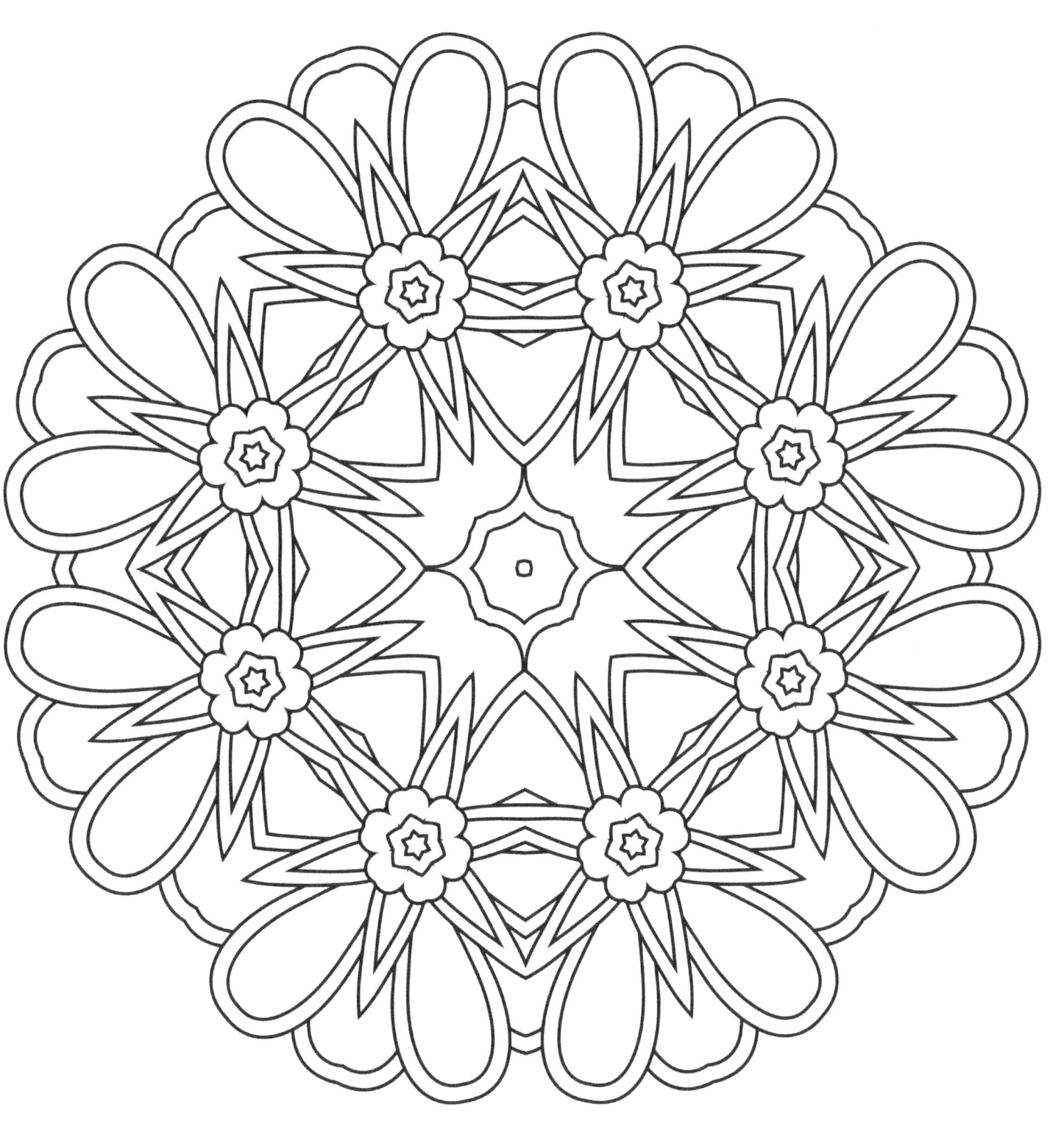

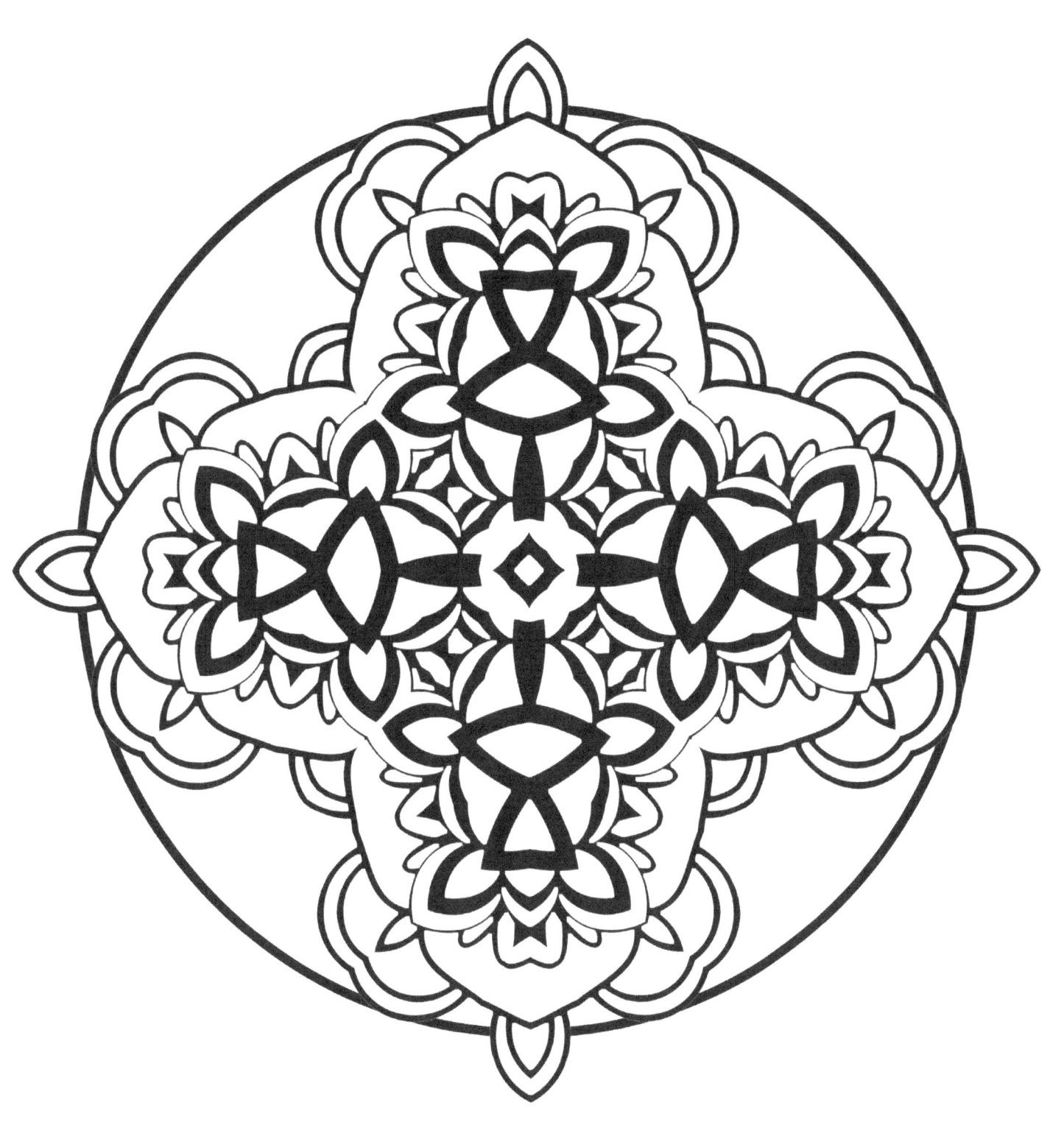

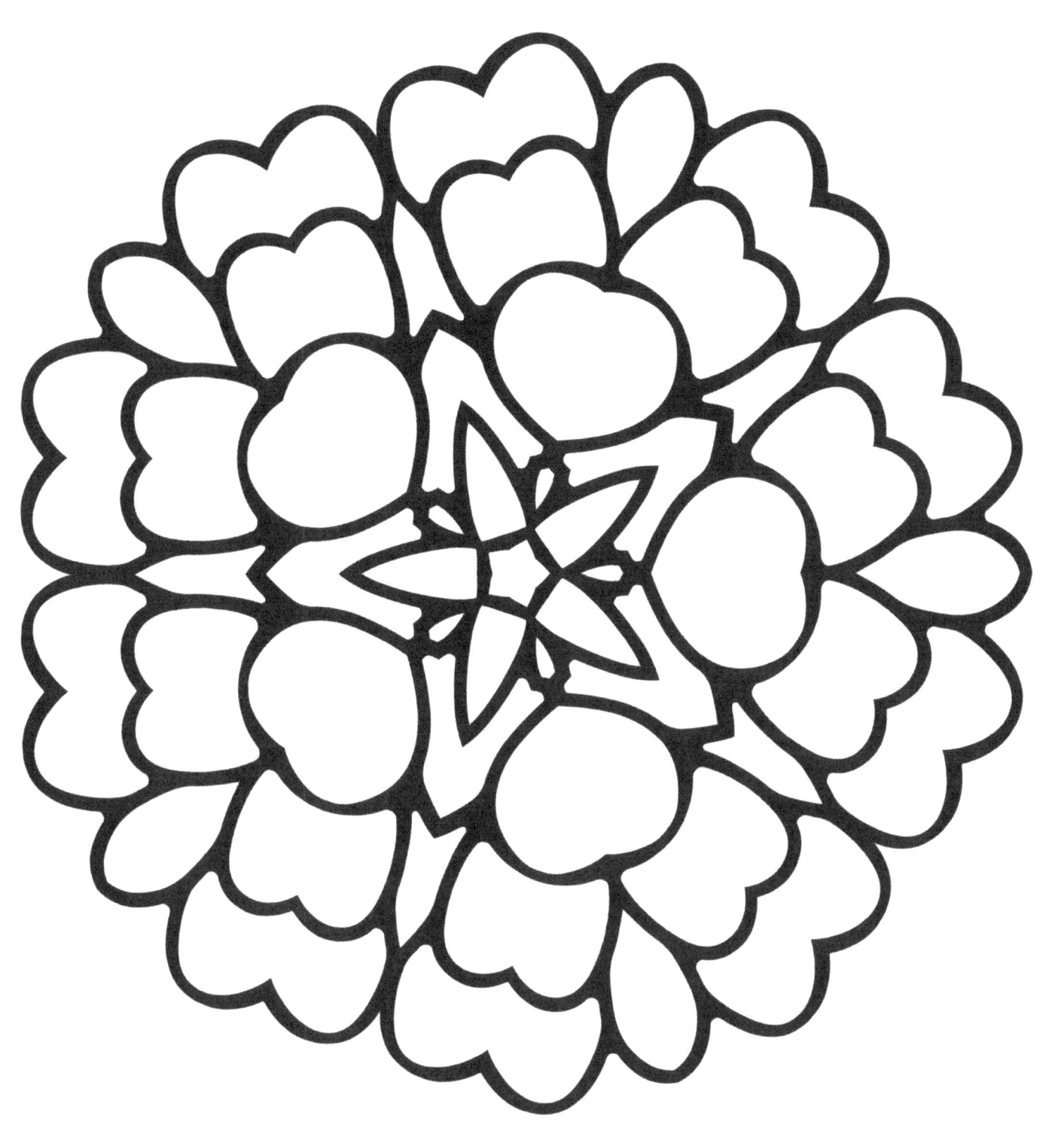

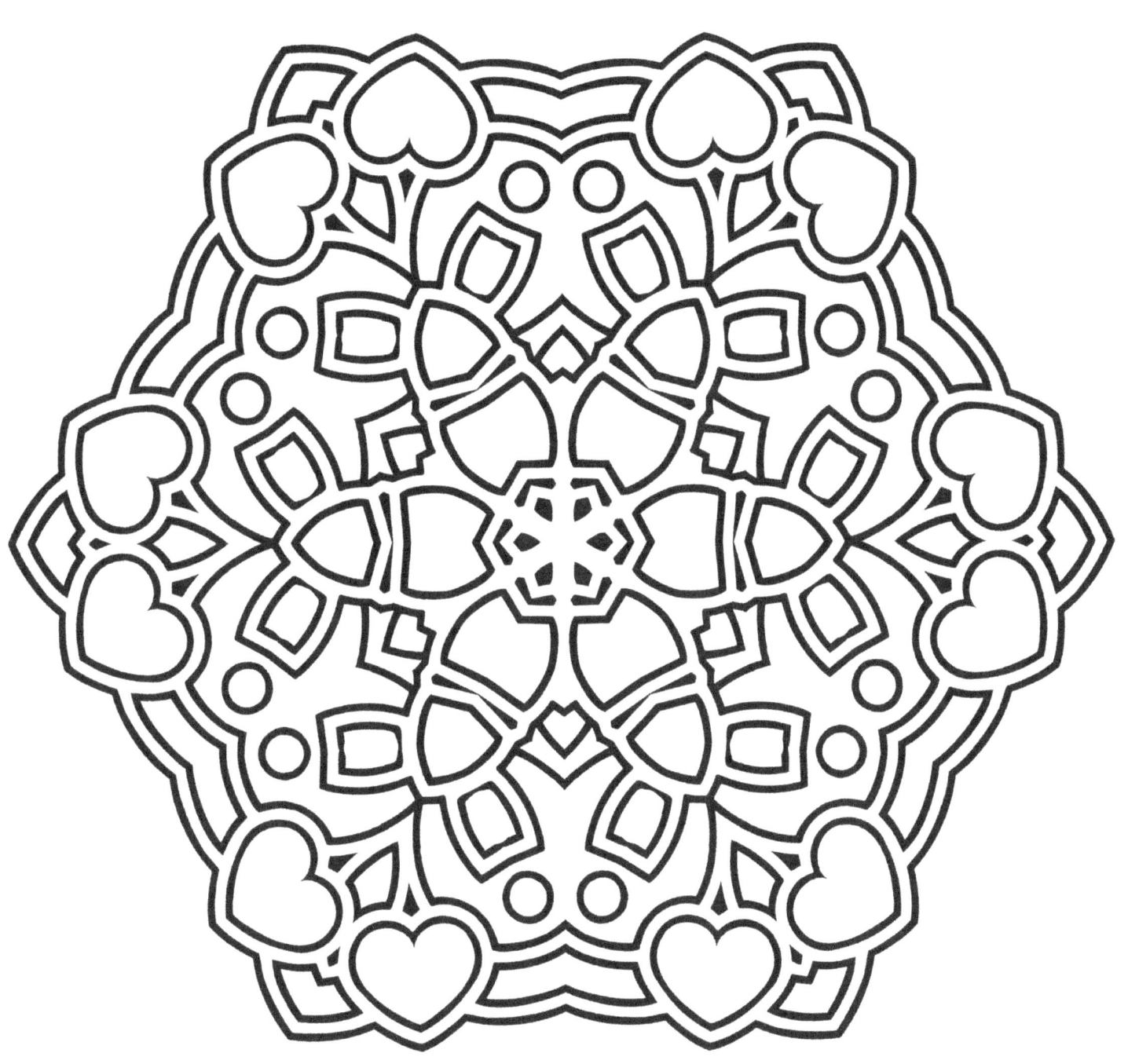

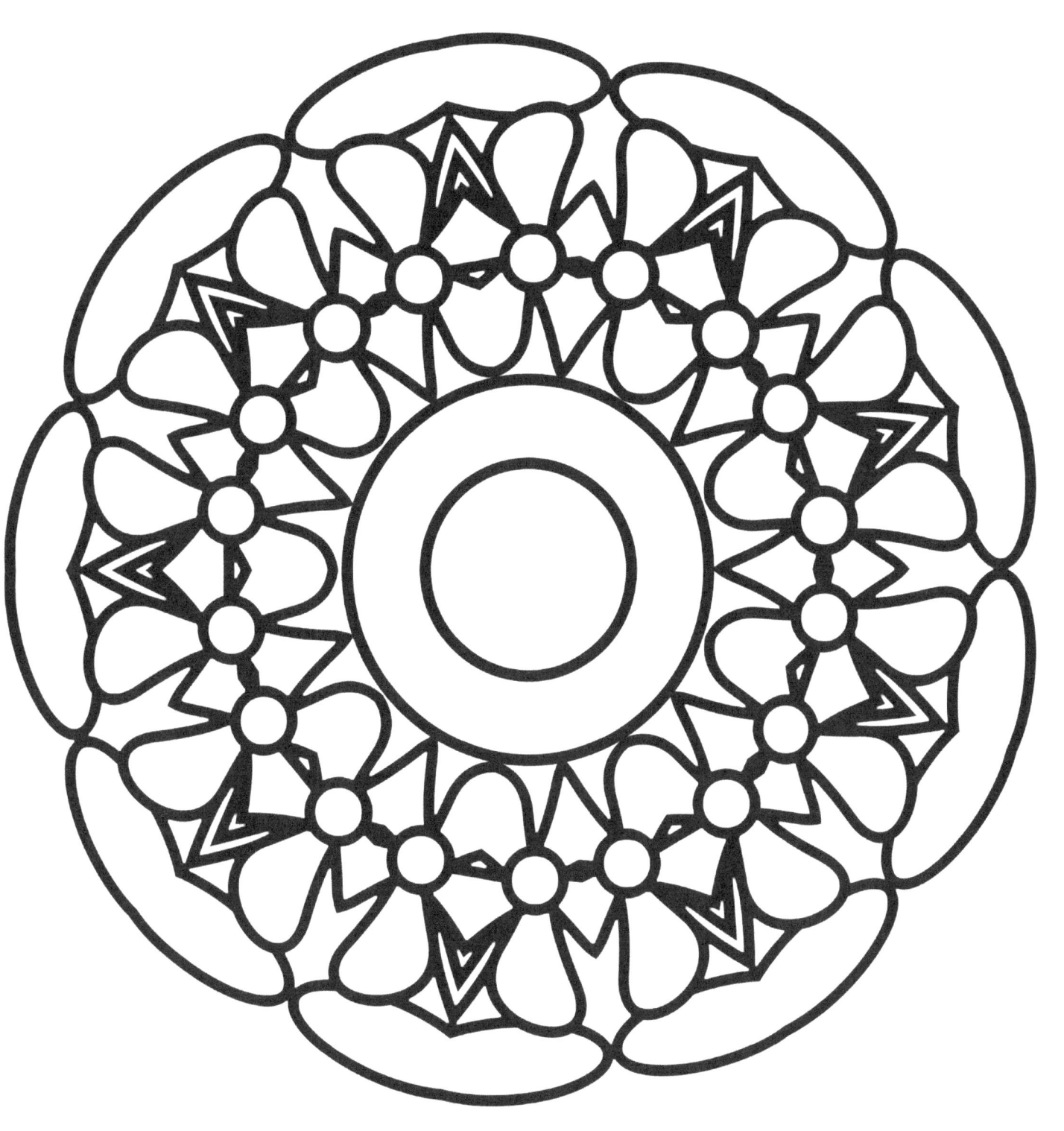

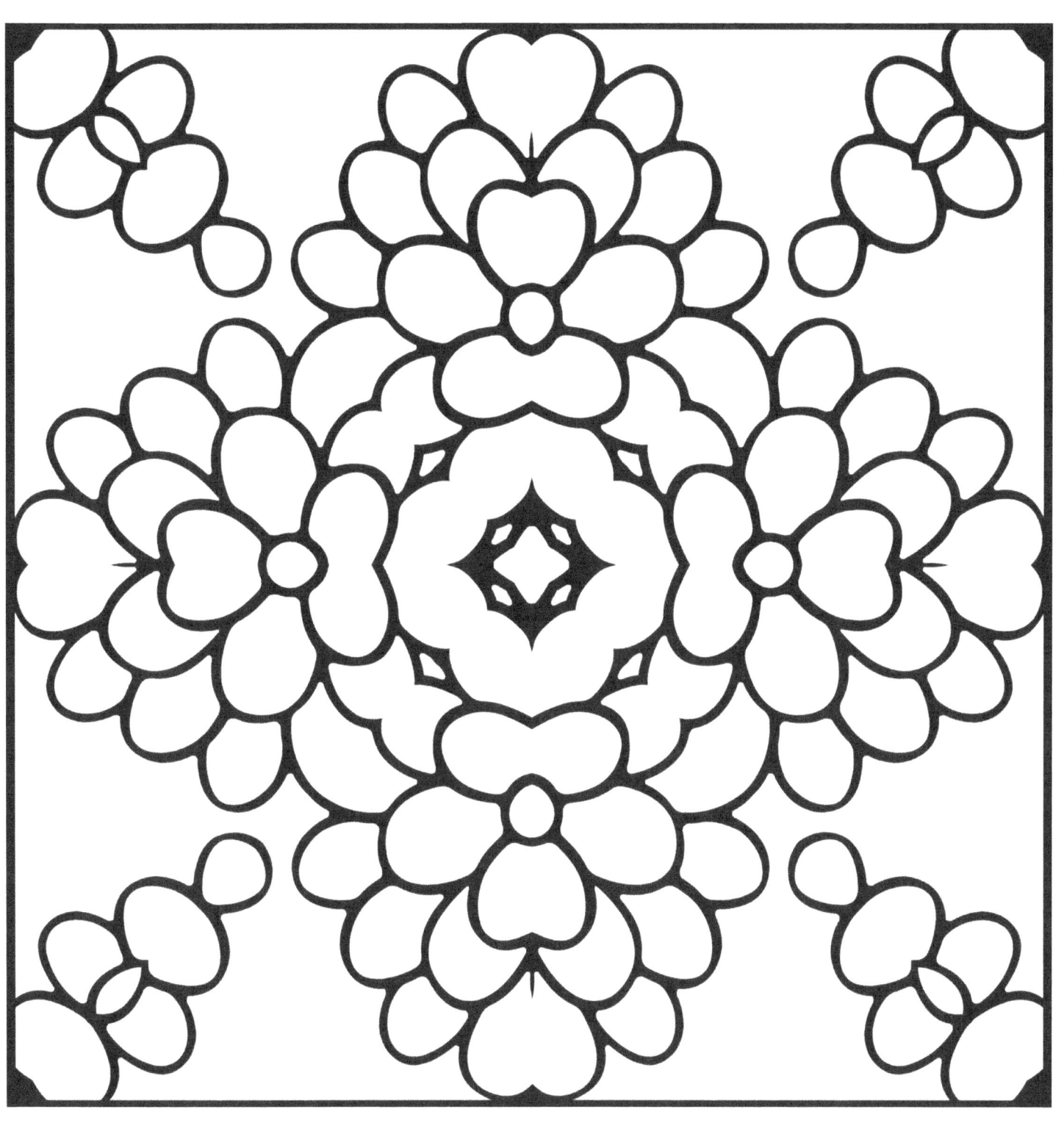

Easy Colorig

Adult Coloring Book

This is Samantha Moore's second book of the "Easy" series. As in the case of "Easy Mandalas", this coloring book for adults is dedicated to beginners, seniors and individuals with low vision. It includes thirty delightful mandalas and kaleidoscopic illustrations. All of them are designed in bolder print and are one sided to avoid bleed-through and allow a relaxing and enjoyable coloring experience.

Enjoy.

Samantha Moore

About Samantha Moore
Since childhood artist Samantha Moore has been experimenting with colors and their influence on mood and relaxation. She has a degree in Graphic Design, a diploma in Art History and is a Reiki certified therapist.

Copyright © 2016 L. Romo. All rights reserved. With the exception of photocopying for personal use and book review, no part of this book may be reproduced in any form without the written permission of the copyright owner.

Easy Coloring
Adult Coloring Book

ISBN-13: **978-1540503121**
ISBN-10: **1540503127**

You may also like:

We would love to receive your comments. Please, find a moment to write a review.

Thank you.

www.ingramcontent.com/pod-product-compliance
Lightning Source LLC
Chambersburg PA
CBHW081252180526
45170CB00007B/2395